THE Colors OF Lobstering

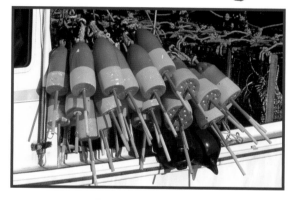

Greg Currier

DOWN EAST BOOKS

Designed by Chilton Creative

ISBN-10: 0-89272-731-4
ISBN-13: 978-0-89272-731-5

5 4 3 2 1

Printed in China

Down East Books
Camden, Maine
A division of Down East Enterprise,
publishers of *Down East* the magazine of Maine.
Book orders: 800-685-7962
www.downeastbooks.com
Distributed to the trade by National Book Network, Inc.

Library of Congress Control Number: 2006933152

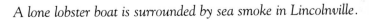

A lone lobster boat is surrounded by sea smoke in Lincolnville.

Dedication

This book is dedicated to the Maine
men and women who put themselves
at risk lobstering so that we may all
enjoy the abundance of the sea.

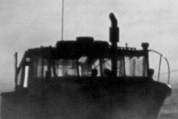

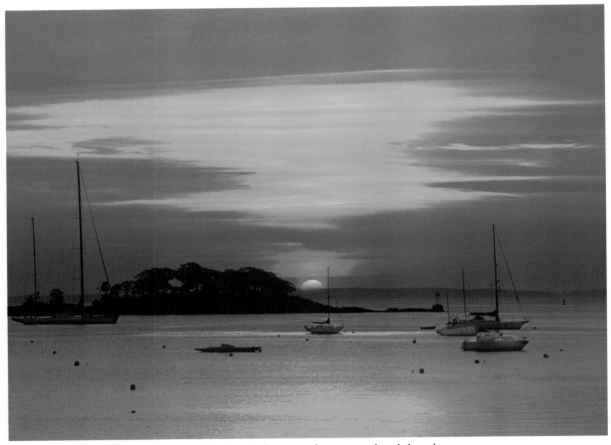

The light of of this Camden sunrise bathes the boats and water with subtle colors.

Preface

Much has been written about the life and work of the Down East fisherman. The wit and wisdom of the lobsterman is legendary and his bright slicker and uniquely styled boat defines the Maine coast. I did not want to create a documentary that detailed the lobster industry or the demanding daily work. Instead I wanted to show the beauty of the surroundings and the colors of the everyday experience. As a photographer, I was drawn to the vivid hues of the buoys, ropes, and foul weather gear. I saw, too, the unique perspective lobstermen have as they go to their work each day. I found a stirring and peaceful inspiration in the brilliant dawns with solitary boats slicing the soft red carpet created by the rising sun on the sea.

I was compelled to record these colorful images because I wanted to share what I saw. There were many days in years past that I was unable to see the sunrises, record the newly painted buoys, or watch the light play with shadows on the gear. For those who are similarly confined to work indoors or are "from away," I offer this perspective on Maine's unique industry.

These images are created without painting in colors or moving boats around with the flick of the mouse. Although I had to go back to a spot many times to get it just right, the colors I saw were as you see them in this book. I seldom use filters, and when I do, they are to remove glare or reduce contrast, not to shift the colors. All of these images were taken with a film based Nikon camera.

Welcome to the colorful world of the Maine lobsterman!

Greg Currier
The Colors of Lobstering

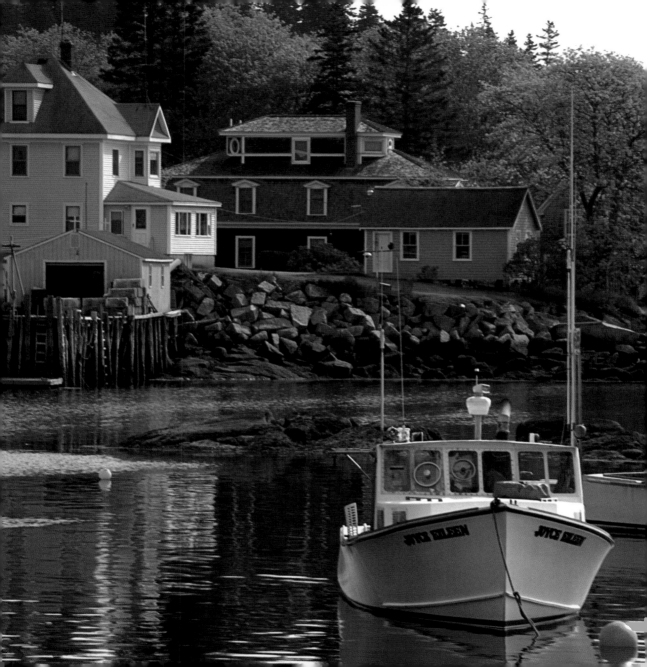

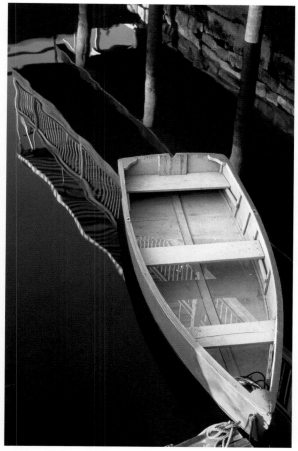

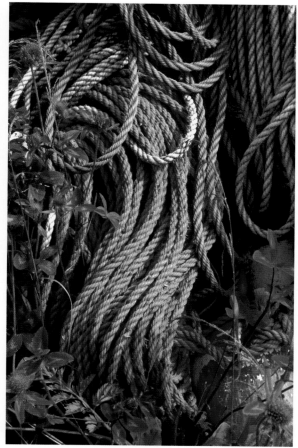

After a night's rain, the dock is reflected in the water in this dinghy at Camden.

New clover grows around these discarded ropes and buoys.

Summer homes overlook the working harbor of Stonington.

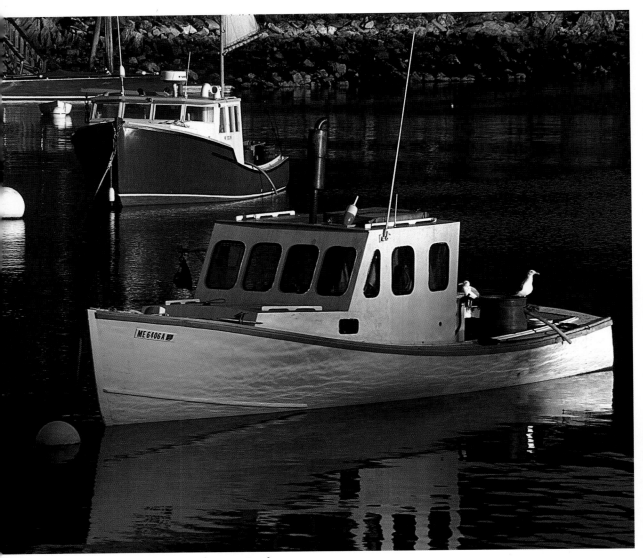

Two gulls are attracted to this boat in Rockport.

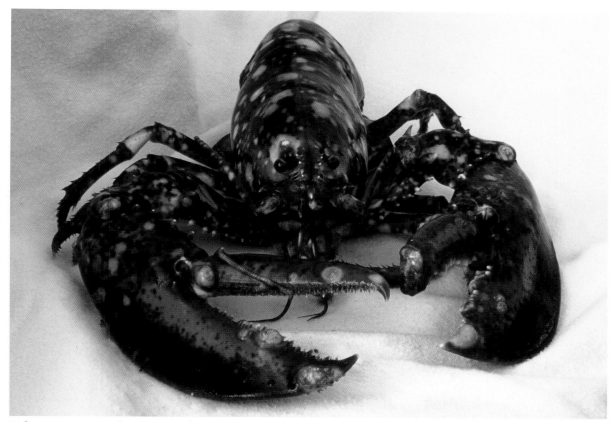

Lobsters sometimes have unusual appearances, such as this polka-dot covered one in Rockport.

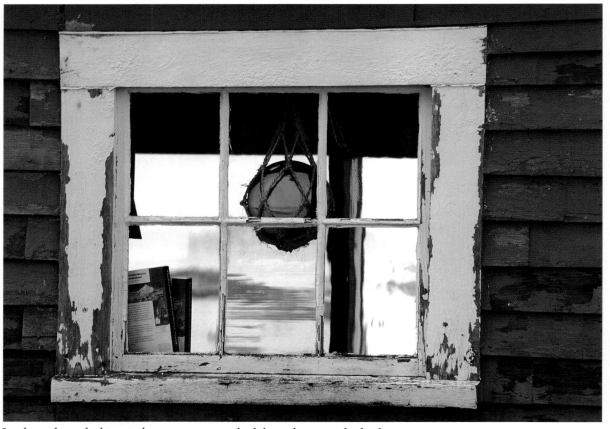

Looking through this window one can see the lobster boats in the harbor.

Fog is a frequent sight in Maine, isolating these Camden boats in Penobscot Bay.

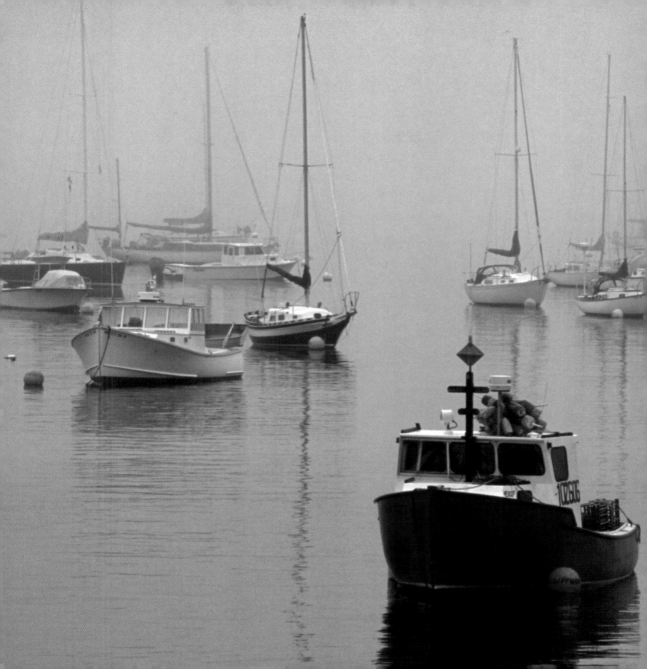

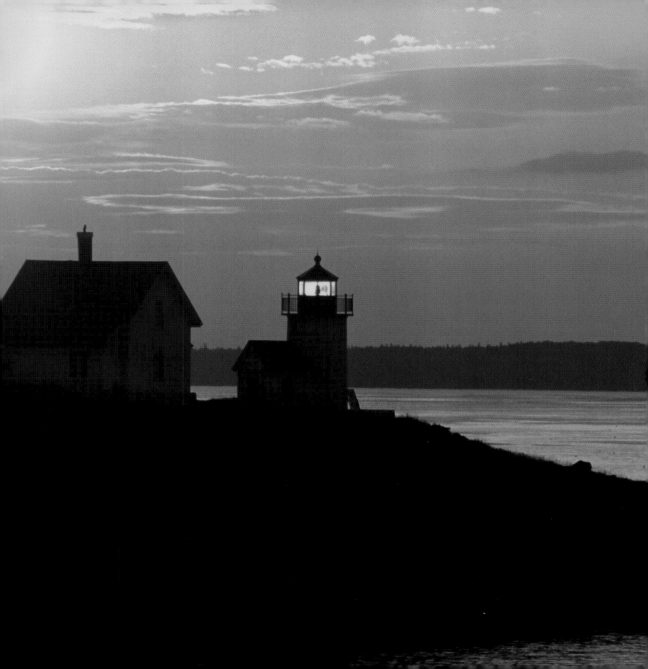

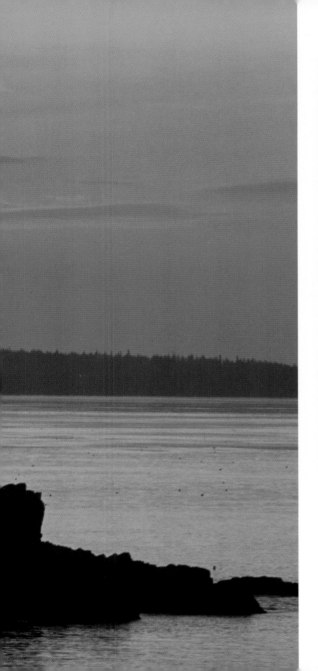

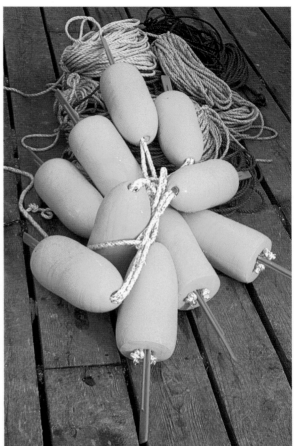

This tangle of buoys and ropes sits on a dock at Port Clyde.

Despite the electronic equipment used to find one's way at sea, there is always something reassuring about the sight of a lighthouse to guide one home.

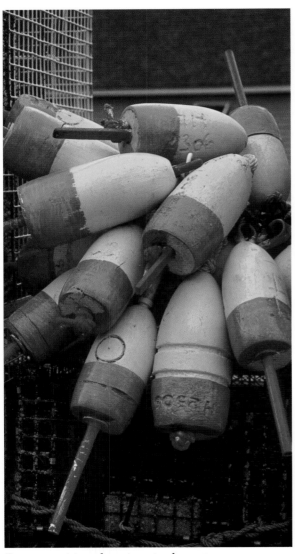

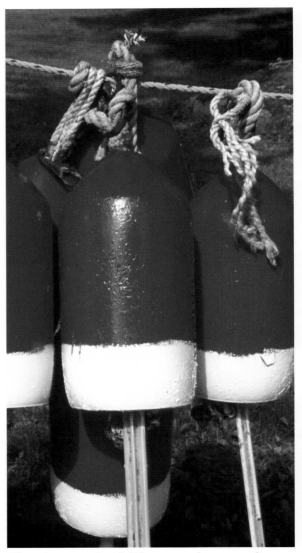

Buoys *awaiting placement in the traps at*
New Harbor.

These buoys *in South Thomaston hang on a line to*
dry after a fresh coat of paint.

14

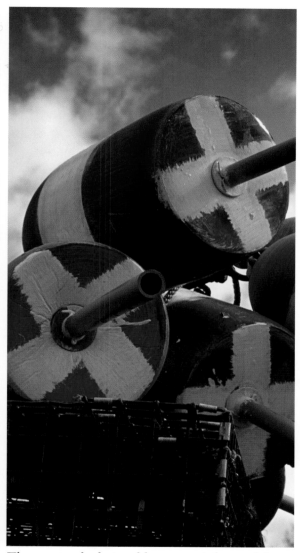

These uniquely designed buoys remind one of the flag of Sweden.

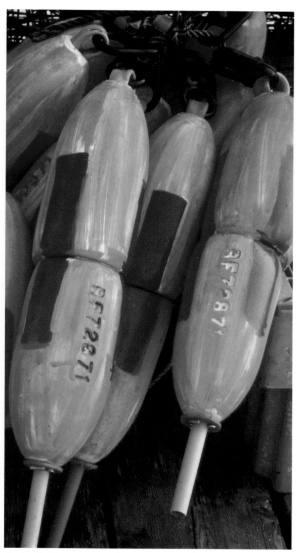

Colorful buoys stand out against the gray dock.

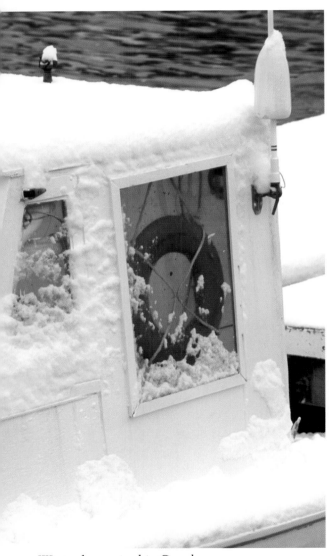

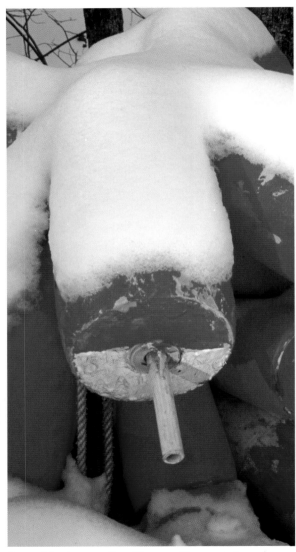

Winter has arrived in Camden.

Snow blankets a pile of buoys. Come spring, these will be repainted for another season.

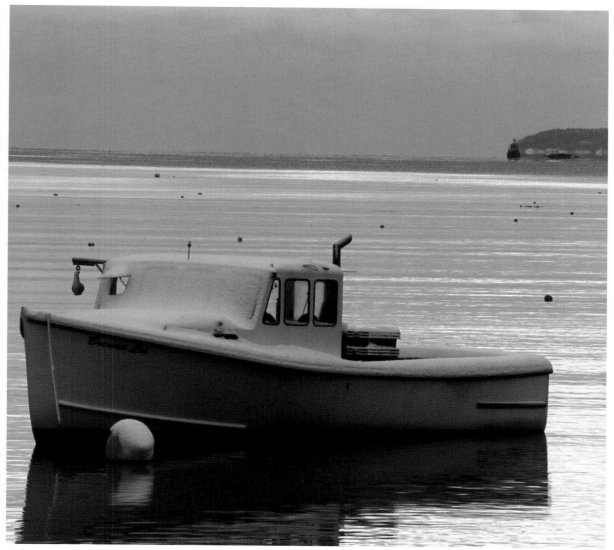

A lone lobster boat greets the winter sunrise in Rockport harbor.

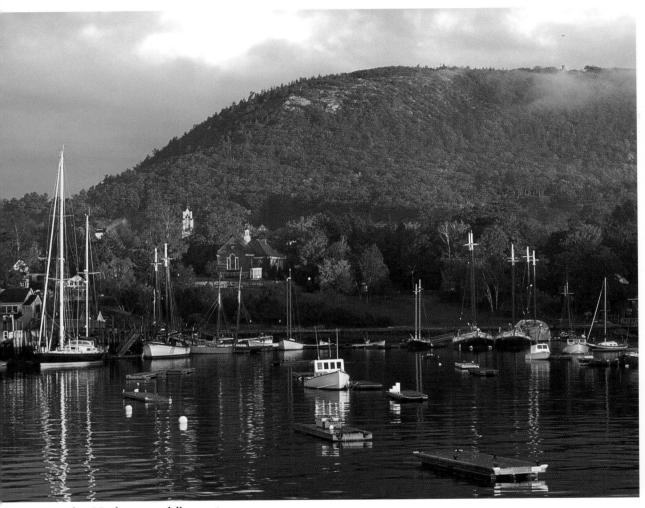

Camden Harbor on a fall morning

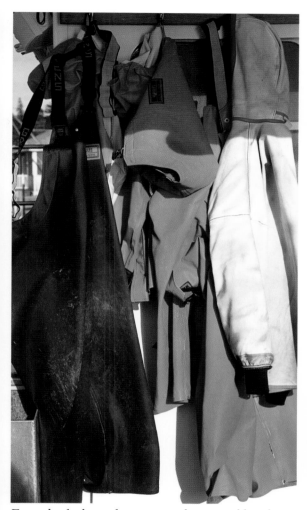

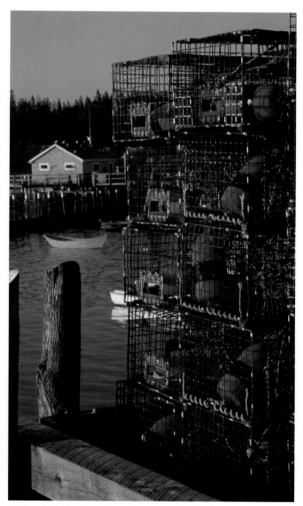

Even the foul weather gear used at sea adds color.

A loaded dock with a dory in the harbor.

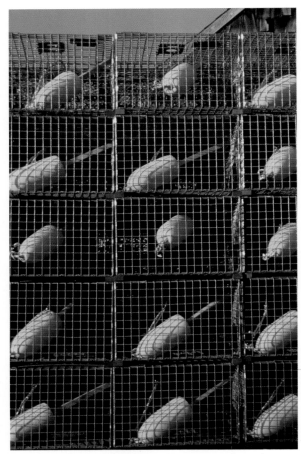

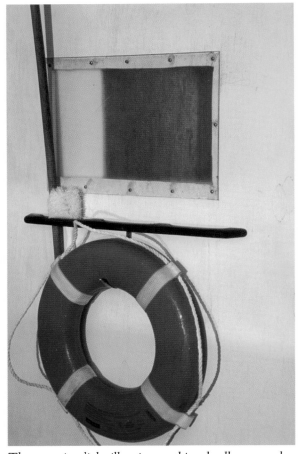

Traps are stacked with their buoys stored inside before being loaded on a boat.

The morning light illuminates this wheelhouse and its life ring.

The low angle of the sun at sunrise illuminates the windshields of the boats in Camden Harbor.

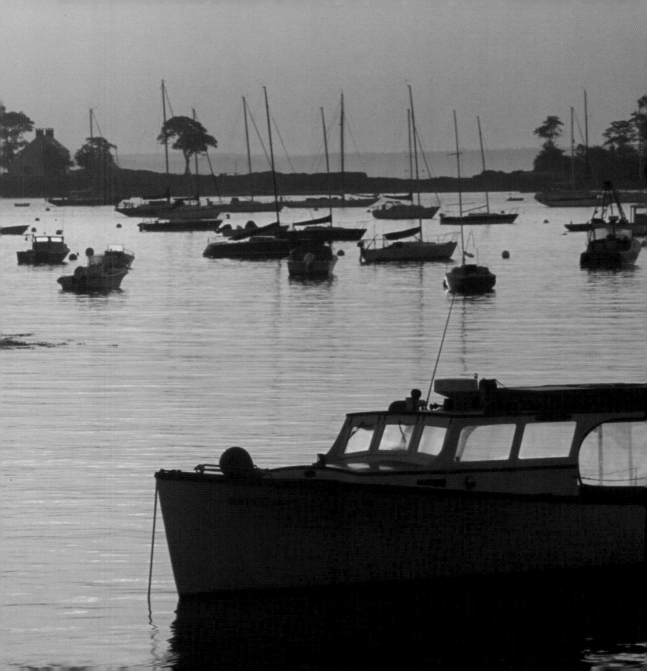

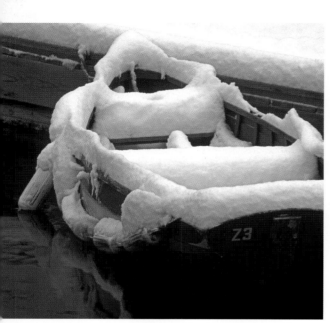

This dinghy at Camden is blanketed by a sudden winter storm.

An early winter storm lifts as dawn greets the fishermen.

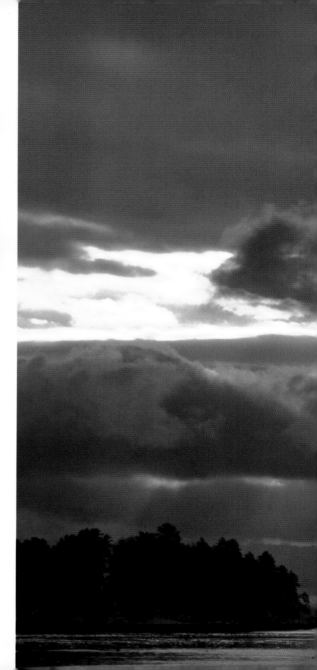

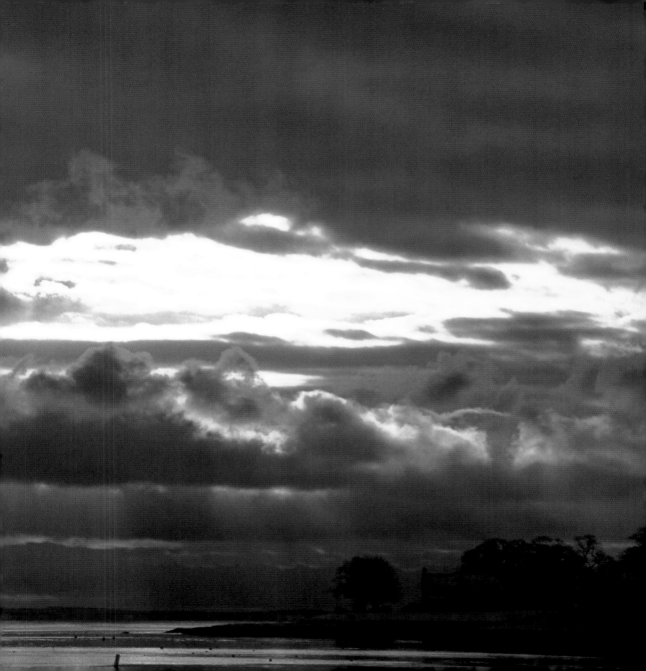

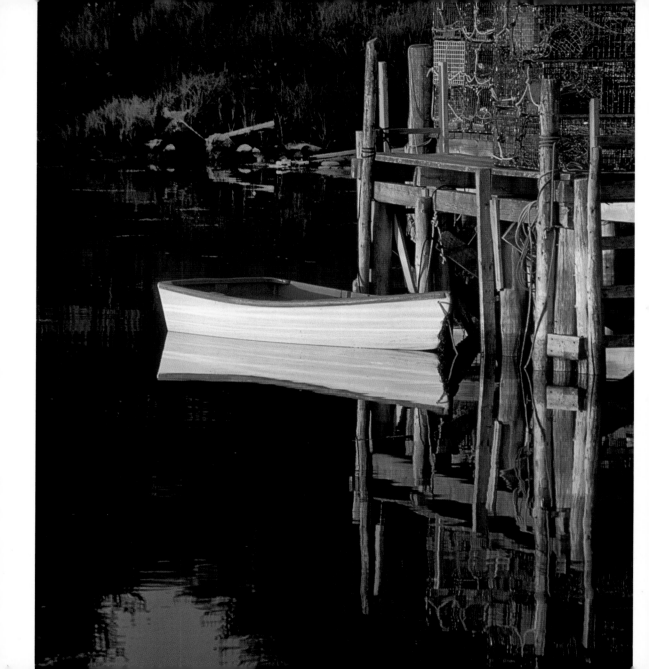

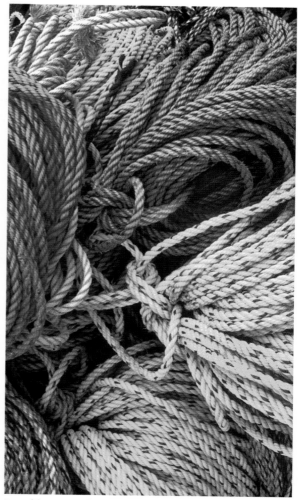

A passing boat distorts the reflection of a dock in Camden.

In addition to the myriad colors of buoys and boats, the ropes also add their own variety of colors.

This dinghy at Port Clyde is reflected in the still water of the protected harbor.

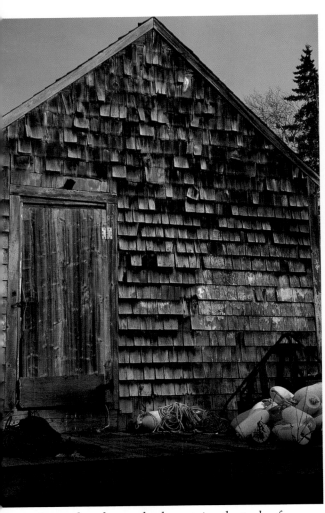

A *weathered gray shack contains the tools of
the trade.*

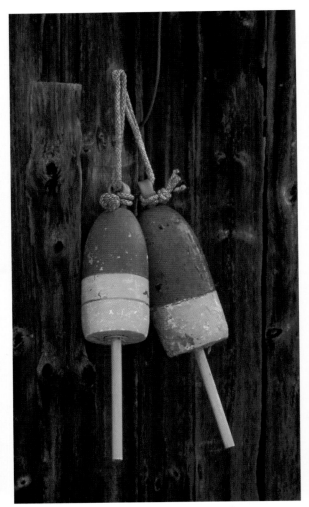

These *well used buoys hang on a shed door in
New Harbor.*

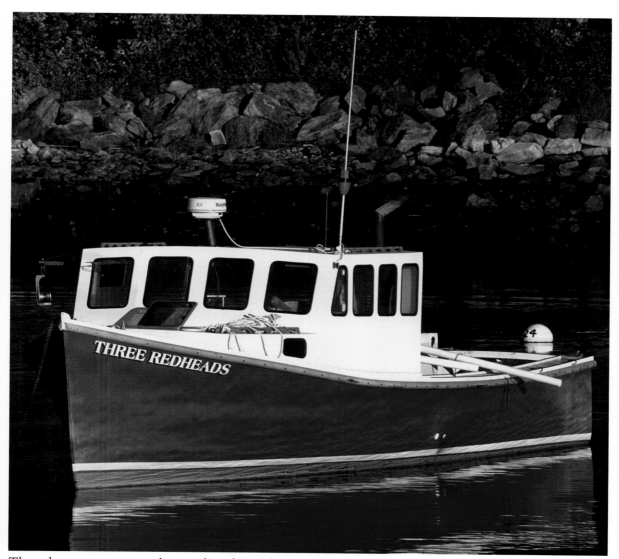

The red summer sunrise enhances the color of this lobster boat in Rockport Harbor

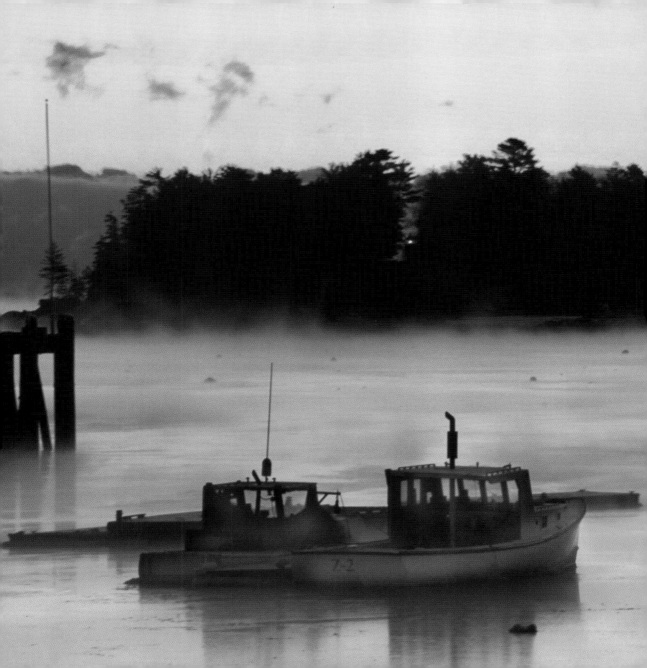

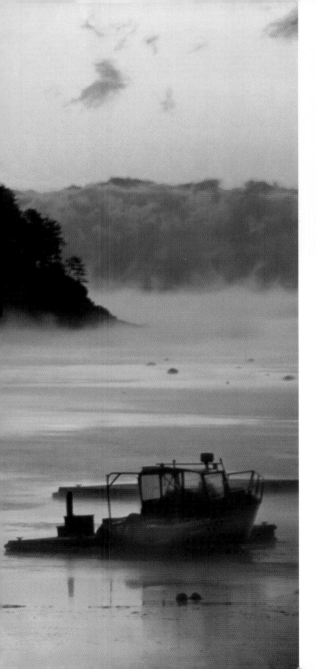

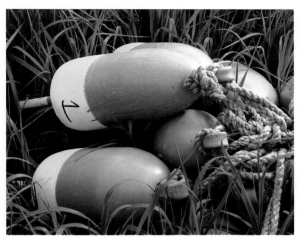

These colorful buoys in the new spring grass look like Easter eggs in a basket.

Sea smoke, such as this around Curtis Island, is a phenomenon created by cold air over warmer water. As the water evaporates it creates the smoke like appearance. It is most pronounced at the first sudden cold snap on a still day.

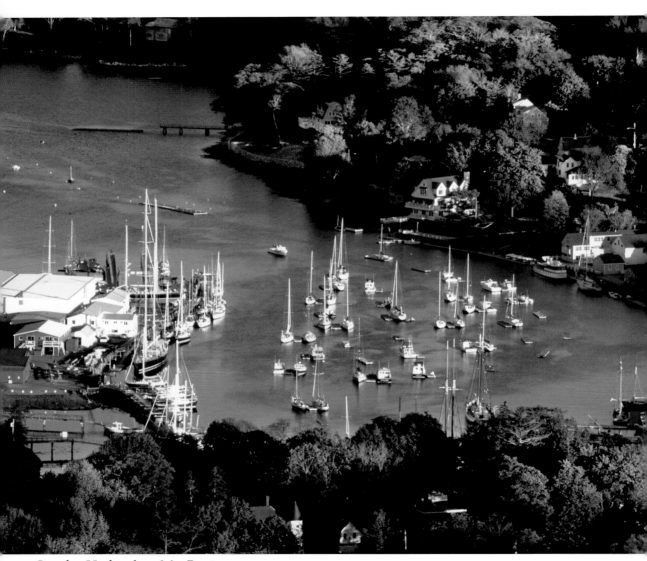

Camden Harbor from Mt. Battie

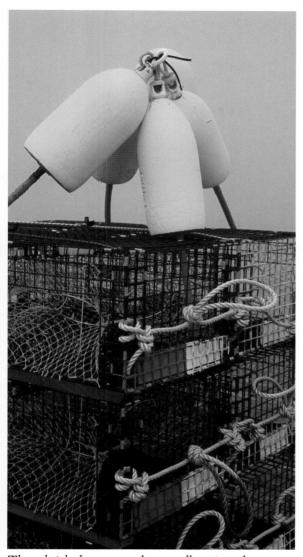

These bright buoys stand out well against the gray of the fog.

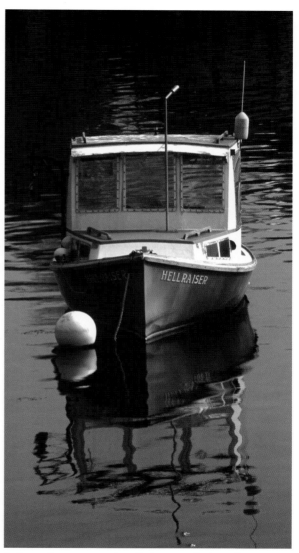

Lobster boats come in all sizes, including this small one.

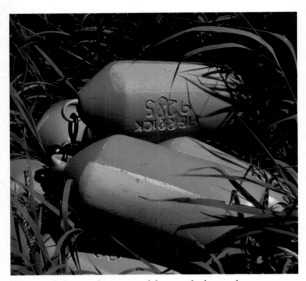

These elaborately painted buoys hide in the summer grass.

Low fog lifts on a summer morning in Stonington.

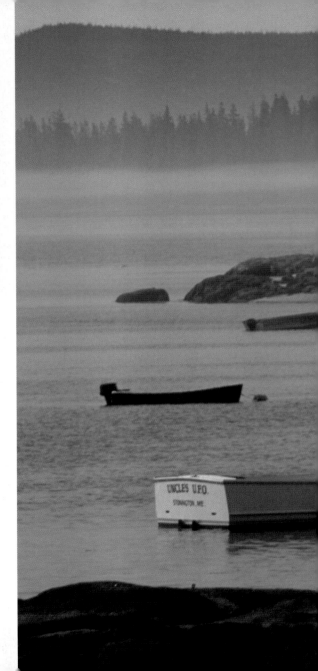

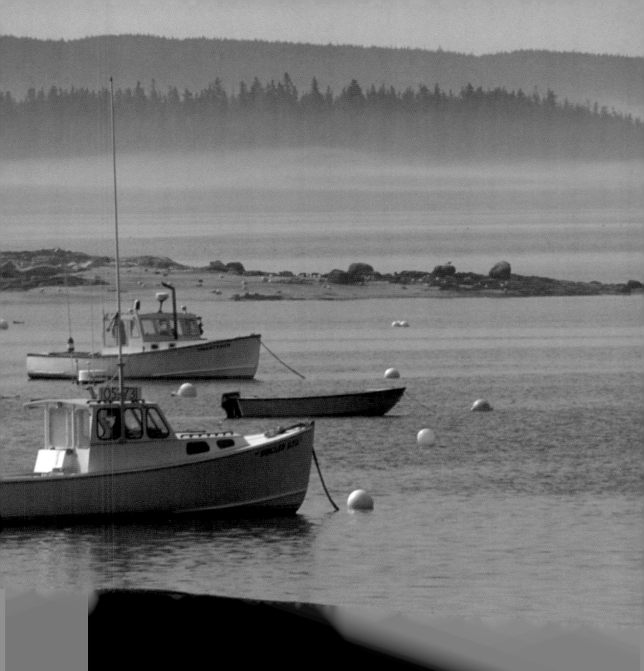

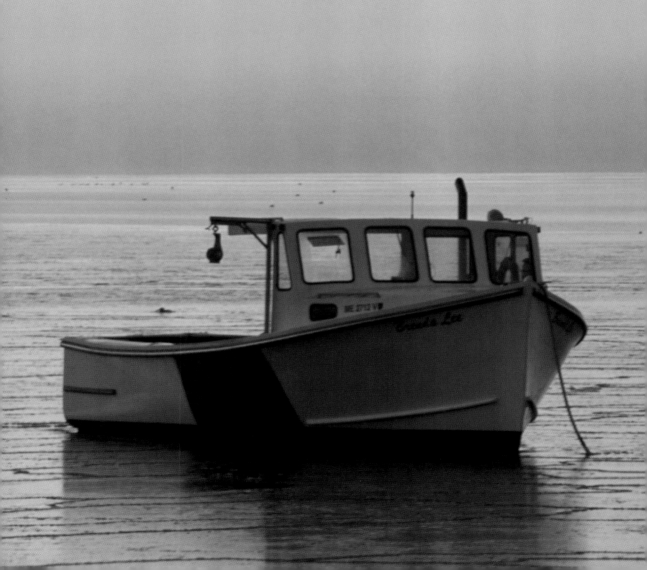

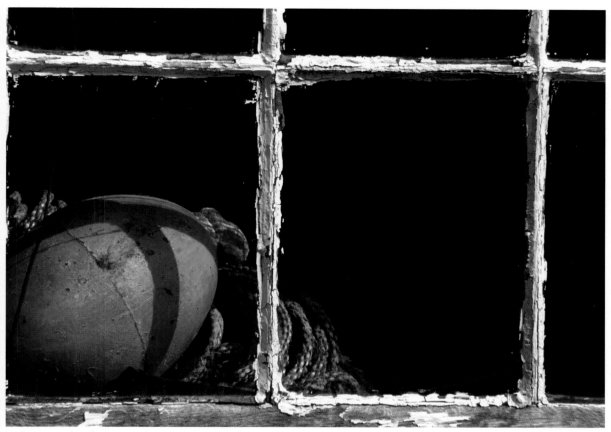

A lone marker buoy can be seen through the weathered window of this shack.

Winter sunrise reveals a lobster boat
frozen in place.

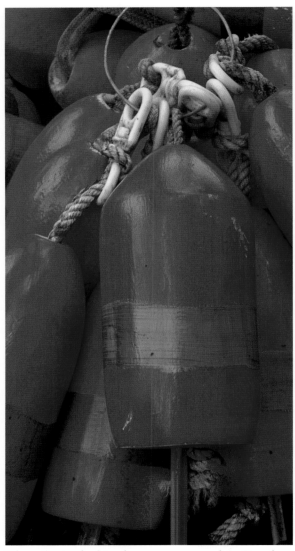

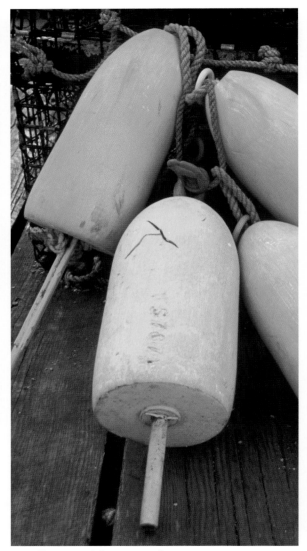

These festive looking buoys were stored in Camden.

A collection of fluorescent buoys contrasts against the gray dock.

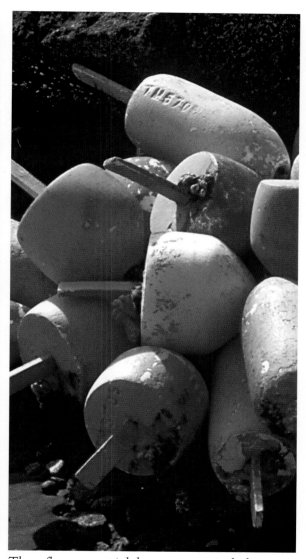

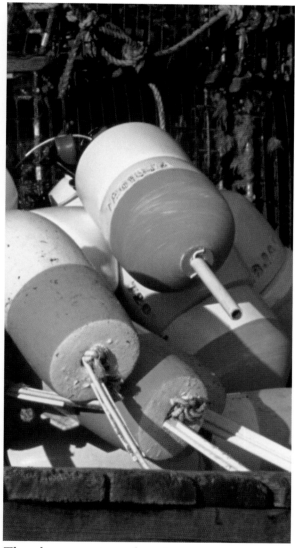

These fluorescent pink buoys are particularly striking against the dark rocky shore.

These buoys await another trip out to sea.

37

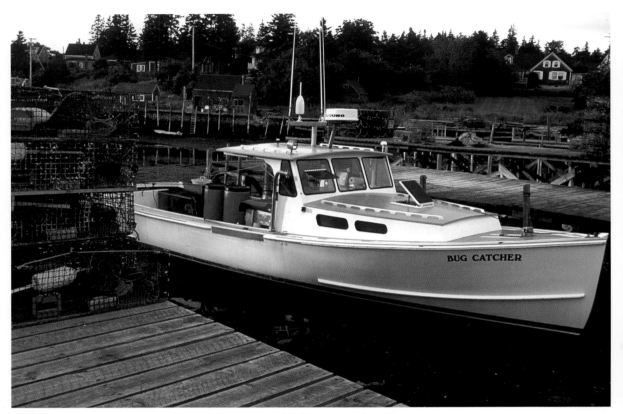

This lobster boat at Port Clyde is taking on traps and awaiting the tide.

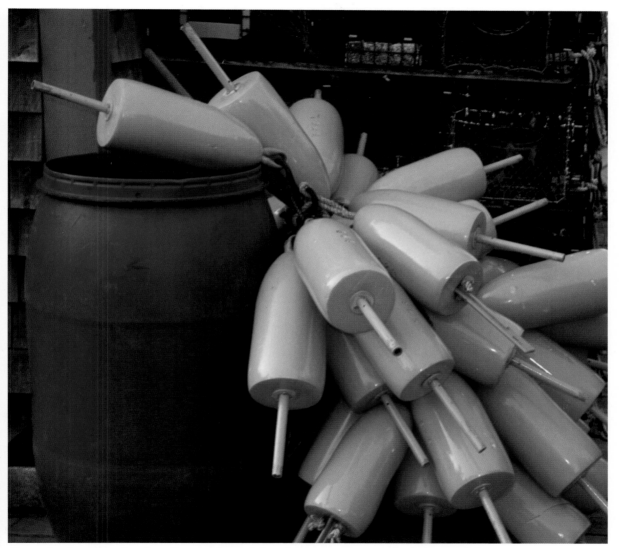

On a cloudy, misty day the vibrant colors of these buoys seem to supply their own light.

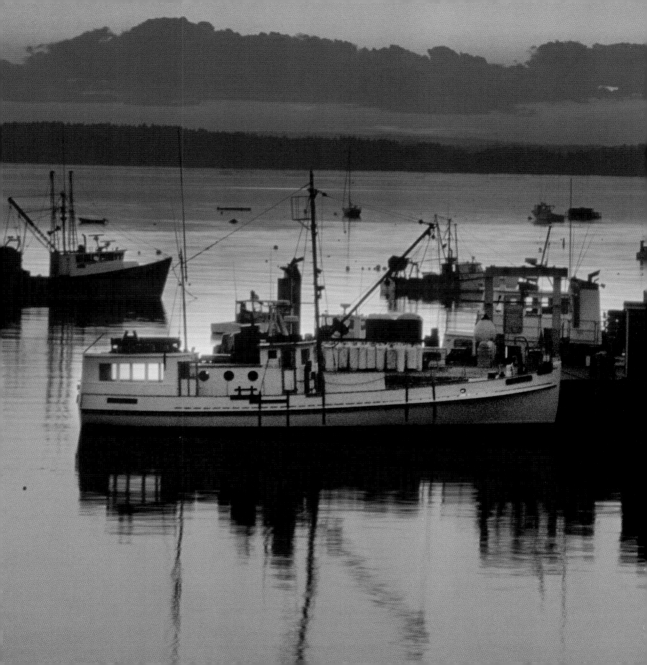

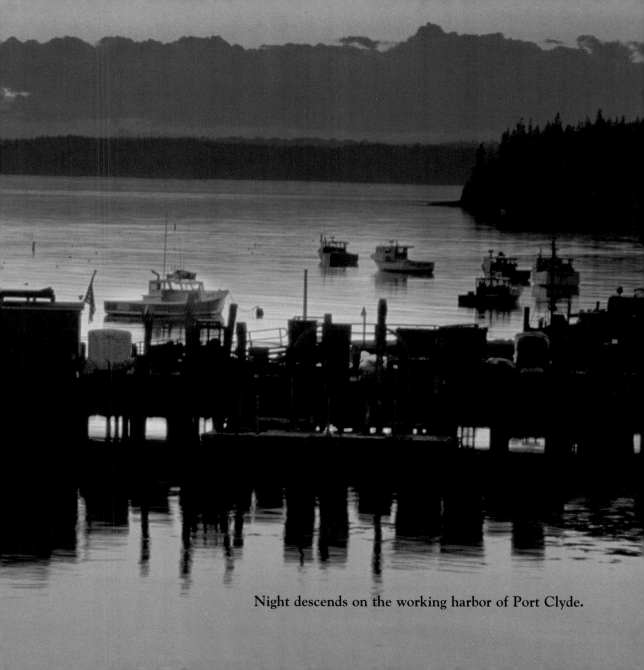

Night descends on the working harbor of Port Clyde.

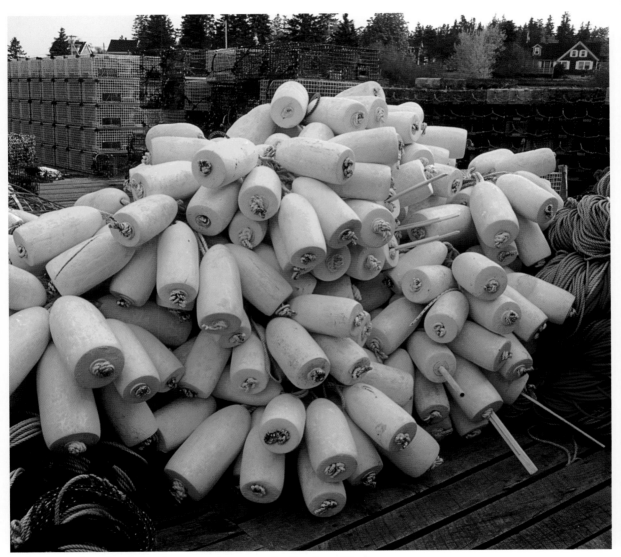

A large supply of buoys and ropes waits on a wharf at Port Clyde.

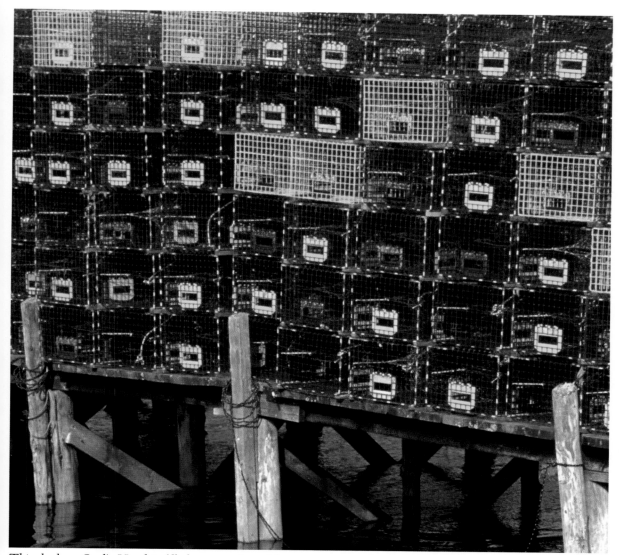

This dock at Owl's Head is filled to capacity with traps, awaiting loading on a lobster boat.

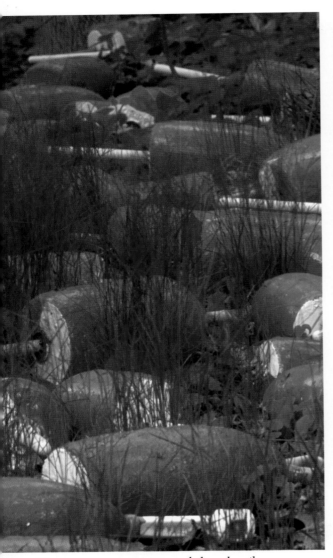

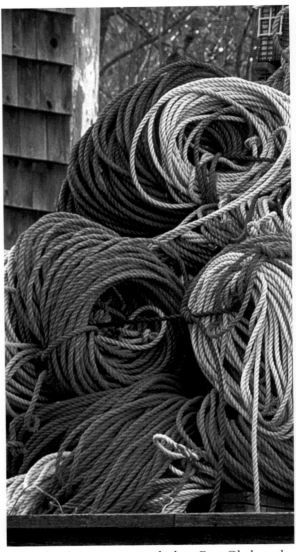

New grass grows up around these hastily discarded buoys from the previous season.

A tangle of ropes sits on a dock at Port Clyde and an ice pattern in Camden reflects a cold snap.

44

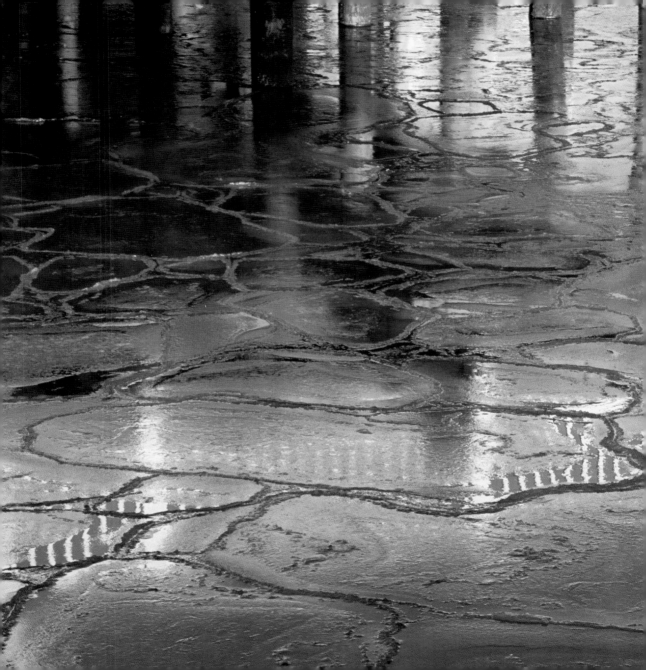

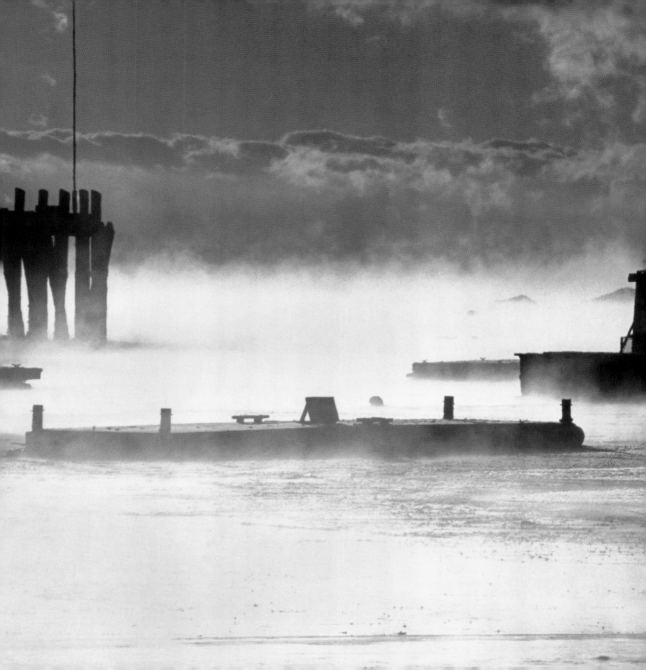

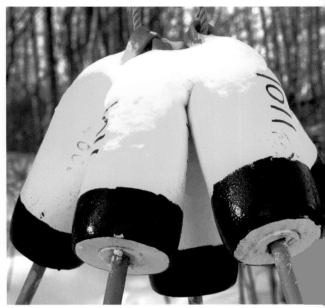

Lobster buoys hung on a line for the winter hold the new-fallen snow.

One lone lobster boat waits out a cold January morning in Camden.

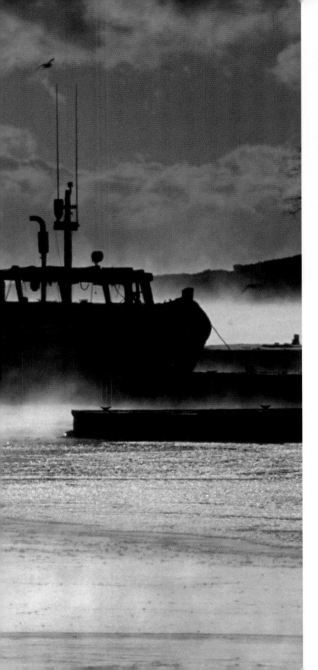

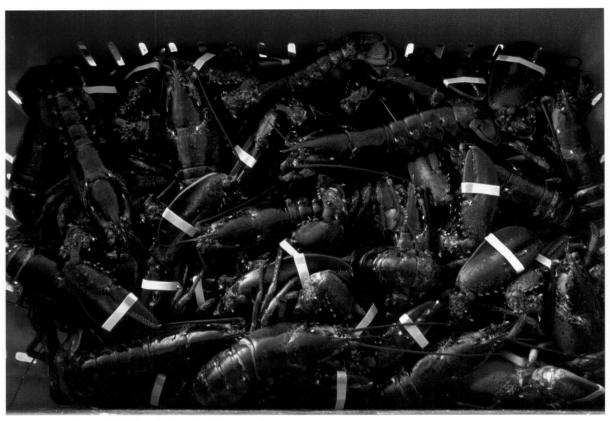

A crate of lobsters is unloaded in Tenants Harbor.

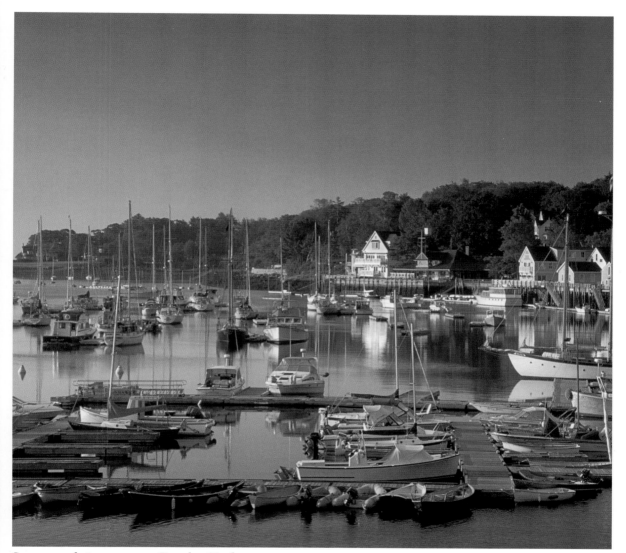

Summer solstice comes to Camden Harbor.

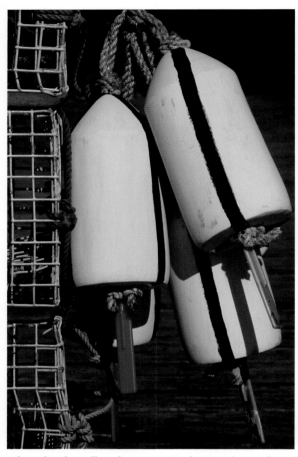

These bright yellow buoys at Owl's Head even have a racing stripe.

The rich winter morning light illuminates the sea smoke in Camden harbor.

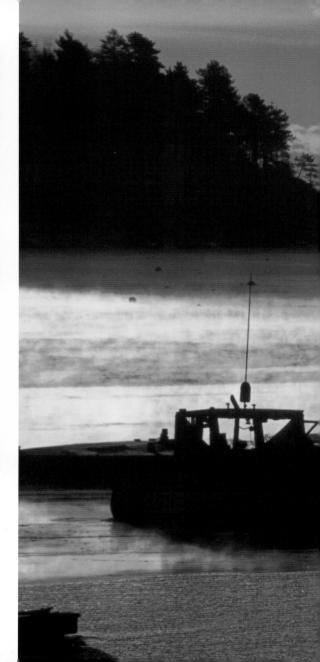

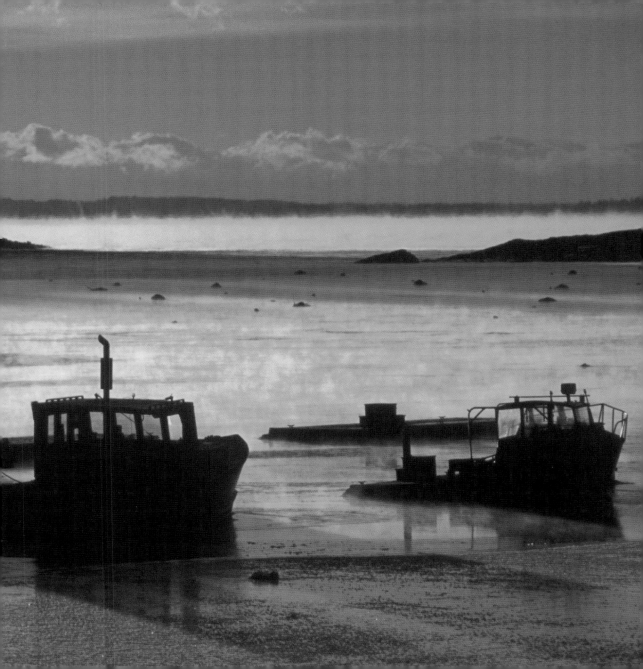

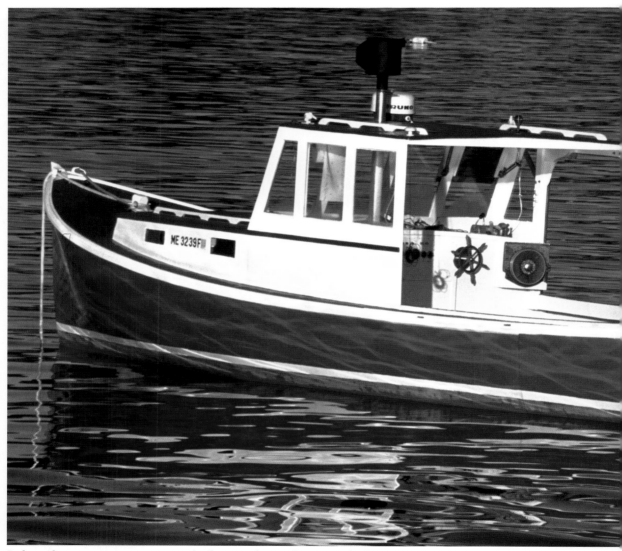

Lobster boats come in a variety of colors, and are often named after women.

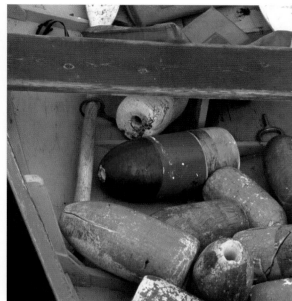

These buoys in a Bar Harbor dinghy await a trip to the lobster boat.

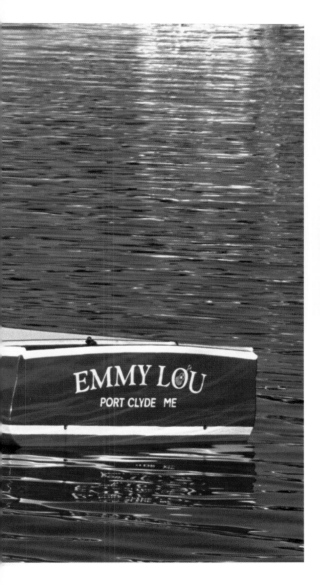

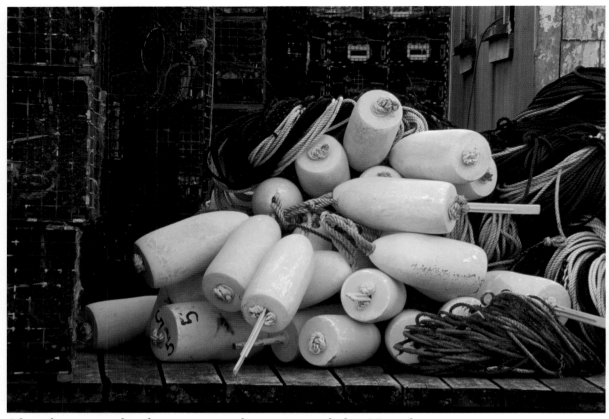

After a long season these buoys, traps, and ropes sit on a dock in November.

Dillingham Point in Camden is shrouded in sea smoke.

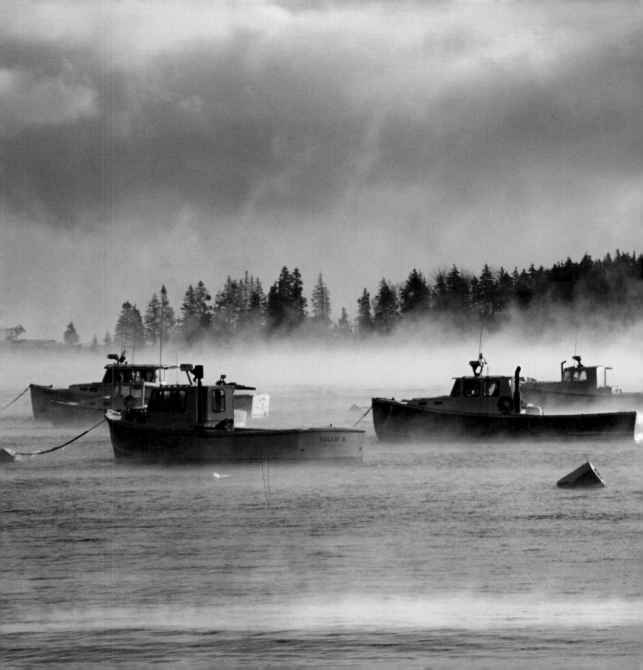

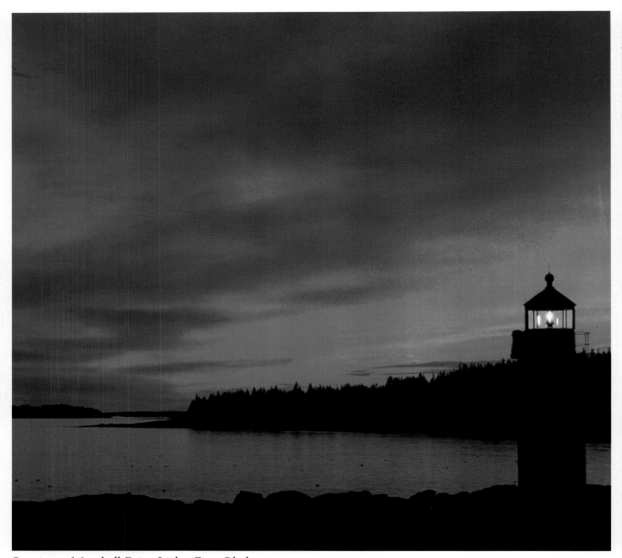

Sunrise at Marshall Point Light, Port Clyde.